Artists' Film and Video of the 1970s

reel work:

Introduction by Dara Meyers-Kingsley

Essay by Chris Chang

Museum of Contemporary Art, Miami

This book has been published for the exhibition *Reel Work: Artists' Film and Video of the 1970s*, organized by the Museum of Contemporary Art, Miami and curated by Dara Meyers-Kingsley.

February 24 - May 2, 1996

Edited by Bonnie Clearwater
Designed by Suissa Design / Miami Beach
Printed and bound in the United States
Edition: 2,000

Library of Congress no. 95-82050
ISBN: 1-888708-00-x

Front Cover: Allen Ruppersberg, *A Lecture on Houdini,* 1973, video, Courtesy the Artist
Back Cover: Robert Smithson, *Spiral Jetty,* 1970, film, Courtesy Nancy Holt
Right: Nancy Graves, *Isy Boukir,* 1971, film, Courtesy the Artist

This exhibition and catalog were made possible by a generous grant from the Elizabeth Firestone Graham Foundation.

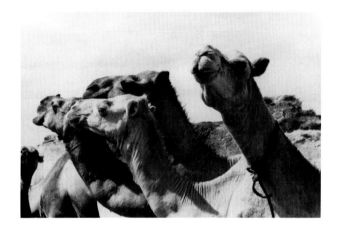

Dedicated in memory of **Nancy Graves**

Reel Work: Artists' Film and Video of the 1970s inaugurates the Museum of Contemporary Art's new ART COURT which architect Charles Gwathmey conceived as an outdoor theater for the arts. The thematic film and video programs, shown over a period of nine weeks, will be screened in the ART COURT on an exterior wall of the museum, creating the relaxed experience of the outdoor movies so popular in the 1950s and 1960s.

Throughout the museum's fifteen-year history, film and video have been a major component of its programming. *Reel Work* is in keeping with the museum's philosophy of creating exhibitions which have a true purpose for being and which have relevance to other exhibitions presented at the museum. The artists' film and video in this series provide a recent historical source and context for the artists in the museum's concurrent inaugural exhibition *Defining the Nineties: Consensus-making in New York, Miami and Los Angeles*.

The Museum of Contemporary Art is proud to bring the curatorial vision of Dara Meyers-Kingsley, director, Film and Video Collections, Andy Warhol Foundation for the Visual Arts. Ms. Meyers-Kingsley's inordinate knowledge of the moving image is realized in her thoughtful selection and thematic programs presented in this exhibition. The museum's chief curator Bonnie Clearwater coordinated the exhibition and catalog production. We would like to thank film critic Chris Chang for his insightful essay; Ana Mele, registrar, for her diligence in obtaining the films and videos; Dorit Arad for her research of photographic documentation; and Fred Singer for his technical advice. We would like to acknowledge Suissa Design, Sue Henger for copy-editing, Dara Friedman for compiling the bibliography and Lynne Gelfman for her proof-reading of this catalog which explores an exciting period of artistic experimentation in film and video. Our appreciation also goes to the artists and lenders to this exhibition for their vision and creative spirit.

A very special thank you to the Elizabeth Firestone Graham Foundation for their generous support of this exhibition and catalog.

I would especially like to thank the Board of Trustees for their support of this important film and video presentation.

Lou Anne Colodny, Executive Director

Acknowledgements

Many thanks to the following organizations and individuals: Sam McElfresh and Kari Olson, American Federation of the Arts; Jim Hubbard, Anthology Film Archives; Josh Baer; David Callahan, Donnell Media Center; Patty Brundage and Maureen Mahoney, Leo Castelli Gallery; Lori Zippay, Steven Vitiello and David Kalal, Electronic Arts Intermix; Marc Nochella and Frayda and Ronald Feldman, Ronald Feldman Fine Arts; Jeannie Freilich, Marian Goodman Gallery; Donald Goddard; Rodney Hill, Jay Gorney Modern Art; Carole Ann Klonarides and Elayne Zalis, Long Beach Museum of Art; Ruth Phaneuf, Nicole Klagsbrun Gallery; Chon Noriega, UCLA; Patrick Painter Editions; MM Serra, Filmmakers Coop; Marcia Tucker, The New Museum of Contemporary Art; and Mindy Faber, Video Data Bank.

Thanks to the artists for their cooperation and their pioneering work.

Thanks to my colleagues at the Museum of Contemporary Art: Lou Anne Colodny, Bonnie Clearwater and Ana Mele who made the realization of this exhibition possible.

Special thanks to my colleagues at the Warhol Foundation for their support and to my husband and partner, Evan Kingsley.

Dara Meyers-Kingsley, Guest Curator

REEL WORK: ARTISTS' FILM AND VIDEO OF THE 1970S brings together film and video (primarily tapes) created by some of the best known visual and performance artists during a very rich decade for experimentation with moving images. The artists included are often more renowned for their work in other media, but they picked up cameras in the seventies and created art that was new in both concept and execution.

The artists in REEL WORK were pioneers. They set new standards, created and broke rules as they experimented with new forms of communication made possible with film and video. Those who chose film produced work that bears almost no relationship to Hollywood archetypes, made and shown, as it was, far outside the mainstream. Those who chose video virtually invented a new language, for the seventies were video's very beginnings.

Two decades later, the moving image is finally gaining significant recognition in contemporary art. Museums and galleries are exhibiting more of it. Artists are making more of it. Collectors are buying more of it. This exhibition is a timely opportunity to look at the precedents for a whole new generation of artists who are now making video their primary medium.

Throughout the twentieth century artists have been drawn to the moving image as a mode of artistic expression. Marcel Duchamp, Salvador Dali, Fernand Leger and Joseph Cornell all experimented with film in the first half of this century. Film, and later video, enabled artists to expand their aesthetic, their philosophy, using a visual medium that stretched over time rather than space. These media have often been used as a forum for very personal self-expression–with artists turning the camera on themselves–to search out and express personal identities.

During the seventies artists were especially drawn to film and video. This was the decade in which artists rejected the tangible art object and began creating ephemeral works using their own bodies as subject and object. Not plastic in nature, film and single-channel video (accessible, easy to use, spontaneous, cheaper than film) provided the perfect medium for expressing and documenting ideas embodied in feminist art, process art and performance art. Autobiographical and political in subject matter, the works often addressed issues concerning the body, personal identity

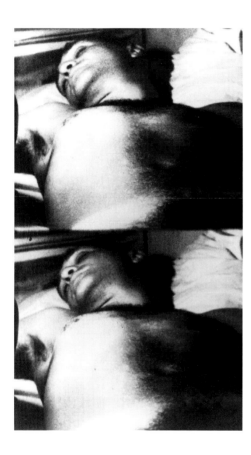

and sexual politics while questioning the very nature of what constitutes artistic practice.[1]

This exhibition is by no means encyclopedic. Work by Nam June Paik and Peter Greenaway, for example, are not included since these artists' primary form of expression is film and video. In a number of cases, work by other well-known artists are not included in the exhibition because the material is in desperate need of preservation. There are also many more film and video works available from the artists included that deserve screening but are impossible to fit into this series. The exhibition is organized into thematic programs and the works chosen fit into the themes discussed below.

Although REEL WORK covers the seventies, the show includes three works from the 1960s by two of the most influential artists of the time: Andy Warhol (working in film) and Bruce Nauman (working in video). Both multimedia artists, Warhol and Nauman came to the art world's attention in the sixties, precisely at the moment that video was born and avant-garde film reborn. For both Warhol and Nauman, artistic expression using moving images was of central concern.

Andy Warhol, the consummate portraitist, essentially gave up painting and became a filmmaker exclusively for a number of years to explore the relationship between artist and model, between filmmaker and subject. Most famous for his use of real time, Warhol made over 400 "Screen Tests," which were unedited 100-foot reels: Black-and-white silent portraits of visitors to The Factory (Warhol's work space) between 1964 and 1966. Warhol's screen test of Marcel Duchamp, shown here, allows the viewer to gaze at the face and personality of Duchamp for three uninterrupted minutes.[2]

Another Warhol film portrait in REEL WORK is the excerpt from *Sleep* made in 1963 (one reel of the 5 hour 21 minute film will be shown). *Sleep* was not filmed in real time, however, but is rather an intricately edited tapestry of short shots and loop (repeat)-printed 100-foot reels of the poet John Giorno asleep. Warhol explores the artist/model relationship while creating a sensual portrait of the nude male body in repose.

Warhol's use of real time and repetition sets the stage for work by many other artists in the seventies. Kim Levin writes: "Video, the gorilla godchild of Andy Warhol's Empire State Building,

Andy Warhol *Sleep* 1963 film Courtesy The Andy Warhol Foundation for the Visual Arts, Inc. New York

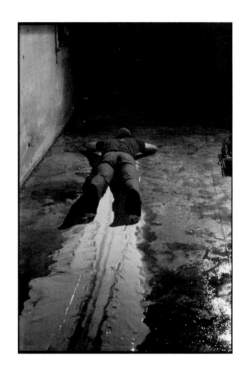

sabotages all attempts at artifice. It stolidly insists on retaining actual time.... When Warhol abolished time in his unmoving movies, it was stupefying. When video records an artist's private activities over a period of twenty minutes, it is endless. If Warhol made boredom permissible, conceptualism institutionalized it."[3]

Like Warhol, Bruce Nauman consistently pushed the boundaries between artistic mediums, abandoning traditional materials and methods of artmaking. Nauman embraced video early and was the first artist to have his tapes sold to collectors and the first to show videotapes in an exhibition in the U.S.[4] Nauman's use of his own body as an object, but not necessarily a subject, in much of this early work precedes a similar objectification in a number of works by artists in the seventies.

David Ross wrote of *Lip Sync* (shown here in an excerpt) that Nauman "used his own body as primary material for the creation of a gestalt, attempting to link the sculptural tradition to the phenomenological aspects of avant-garde dance and related body movement work. This sixty-minute tape… played continuously on a monitor mounted on top of a sculpture pedestal, was not necessarily meant to be viewed from start to finish, but could be approached and contemplated as a sculptural object."[5]

REEL WORK includes a diversity of work that use a variety of formal strategies to address the most prevalent themes of concern to artists at the time. The programs group work thematically but there is much overlap between themes. In other words, the artists' works often fit into any number of programs.

For example, a number of artists address sexual politics and the body as they relate to issues of gender and to feminist concerns. Martha Rosler selects the kitchen as the locale for gender battles, with Rosler wielding kitchen implements like weapons in a Julia Child-like program. Hannah Wilke and Vito Acconci seduce the viewer with their unique brand of "come-on," while Yoko Ono in *Fly*, and Lynda Benglis in *Female Sensibility*, expose and expand the terrain of female eroticism in their provocative work.

The body in performance is central to the work of the seventies. Along with several other artists in this exhibition, Wilke, Acconci, Burden and Oppenheim are the performers in their works.

Whereas Wilke's and Acconci's performances are sexually charged, Chris Burden and Dennis Oppenheim push the limits of biophysical endurance. In contrast Robert Morris choreographs an entire cast of figures in a Midwestern landscape, creating a cinematic scatter-piece in *Wisconsin*.

A number of the works in the exhibition bring out the relationship between artistic process and product. Yoko Ono's non-exhibition in *Museum of Modern Art Show* and Gordon Matta-Clark's chain-sawed derelict buildings make the viewer think about what constitutes artistic practice. In their compilations, John Baldessari, Lawrence Weiner, and Bas Jan Ader all enact single ordinary activities that make the viewer question the very nature of art.

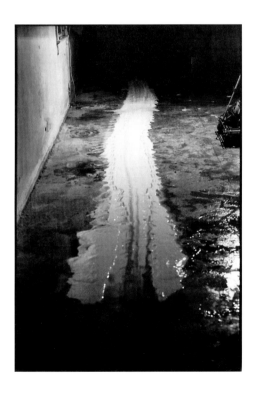

Some artists take humor as a starting point, often confronting the viewer with actions that are silly and/or provocative. Using his now-famous Weimaraners in video skits, William Wegman makes the viewer laugh at behavioral tricks, while Paul McCarthy pokes fun at popular culture and the act of painting, and Edward Ruscha comments on California culture in *Premium*. These works make the viewer question: What is funny?, What is acceptable?, What is taboo?, and What is a joke?

Personal identity and the relationship between the self and the other are explored in biographical and autobiographical works. Family members provide the charged subject matter for Ilene Segalove in *The Mom Tapes*, while Allen Ruppersberg and Warhol look at historical figures, Houdini and Duchamp. Autobiography–artist as subject–is utilized in most works in the exhibition. Eleanor Antin blurs the lines between biography and autobiography in her narrative tape *The Little Match Girl Ballet*.

Still others are interested in the ways media creates new forms of communication with an audience. Keith Sonnier explores the sender-receiver relationship, whereas Richard Serra exposes the way video's cousin, television, manipulates the viewer in *Television Delivers People*. In Serra's *Boomerang* and Dan Graham's *Past Future Split Attention*, formal experiments with the spoken word force performers to interpret simultaneously what they're saying while performing.

Finally, some artists use the moving image as a recording device, exploring its documentary capabilities. Nancy Graves made use of the camera in an almost scientific manner, to record the

Paul McCarthy | *Painting Face Down, White Line* | 1972 | video | Courtesy the Artist

behavioral actions of camels (the subject of her sculptural investigations at the time), while Robert Smithson's documentary is a poetic meditation on the making of his monumental earthwork *Spiral Jetty*.

REEL WORK is intended to reawaken interest in the moving-image art of the seventies and to shed light on the pioneering achievements of the artists and their contributions to the history of film and video. The exhibition succeeds if it accomplishes two competing aims: First, to demonstrate the individual and collective significance of these moving image works from the 1970s, and second, to encourage consideration of the film and tape as integral to an understanding of each artist's entire body of work.

Notes

1. REEL WORK is interesting to consider in light of the art practices of the nineties which witness the reemergence of issues as well as modes of artistic process that were prevalent in the seventies.

2. There are other, much longer silent film portraits in Warhol's oeuvre, most notably *Henry Geldzahler* (1964, 88 minutes) and *Empire* (1964, 8 hours, 5 minutes).

3. Kim Levin, "Video Art in the TV Landscape: Notes on Southern California," *New Artists Video* (New York: E.P. Dutton, 1978), p. 66. This view only takes into account works that document artistic activity and not those videos that are abstract, formal experiments in their own right.

4. David Ross, "A Provisional Overview of Artists' Television in the U.S." *New Artists Video*, p. 150.

5. Ibid.

reel work:

Artists' Film and Video of the 1970s

IN THE LATE 1960S AND 1970S, ARTISTS JUMPED OFF THE SHIP OF CLEAR-CUT CATEGORIES INTO THE sea of multimedia. Classic separations of painting, sculpture, music and dance were seen as stifling, static and, worst of all, oppressive. Boundaries were the enemy. The proliferation of film and video at this point–like a culture growing in a petri dish–was rampant. Moving-image technology was the perfect way to capture the new ideas of social space, time and movement that were seething away behind studio doors and spilling out onto the street. It was an art that was met by furrowed brows. Up until then, things had been pretty easy. Art history, for the most part, behaved in a clean, orderly fashion. Think of Vladimir Nabokov adding a new specimen to his butterfly collection. All of a sudden, with the Civil Rights movement, Vietnam, and various political personalities, there wasn't anything to pin down anymore. Turn on the lights and the butterflies have vanished.

Although each of the artists represented here explored uncharted waters, they were united by a set of interwoven themes:

THE ANTI-OBJECT: The minimalists of the early sixties attacked the sanctity of precious art by turning museums and galleries into showplaces for objects that looked like they rolled off an industrial assembly line. These cold and impersonal works emphasized the idea that the *conditions* making an art experience can be more significant than the art itself. (This stance picked up a thread first spun by Marcel Duchamp.) Seventies post-minimalism pushed for a full blown destruction of the object: Toppled off its high-art pedestal, it fell to earth–shattered, disheveled, and dirty. The point was no longer what the object *was* but how and why it got there. In "process art" common to the period, artists focused on the means rather than the end. This led to the "dematerialization of the art object." As Walter Benjamin once said, "The work is the death mask of its conception."[1]

FEMINISM: In a growing awareness that the institutional powers controlling art (that is, the museums and the galleries) were a mirror of the patriarchal hierarchies of the real world, the work of many artists focused on male domination and control of the female as object. It should come as no surprise that this critique was accompanied by a corresponding rise in visibility of female artists. The strategies included everything from gender role reversals to emphatic acknowledgment of

taboo forms of seduction. In addition, the old world order of an elitist macho boy's club was called into question simply by having artists define it as such. (The seventies saw the crystallization of the women's movement and the watershed Roe v. Wade decision; nonetheless, the concerns are very much alive and visible today in a variety of art, performance and information groups including the Bad Girls, Riot Grrrls and Guerilla Girls.) Of course, the primary institutional unit is the *home* and it is there, as a fundamental location for feminist film and video, that long-established foundations began to crumble.

THE BODY: In the search to reveal the "process" of art, the focus of attention naturally shifted to the human body, the one thing that remains once all the materials of artmaking are stripped away. Naked exposure, both literal and metaphorical, made possible a whole new variety of work characterized by an open honesty and fragility that, up until this point, artists had tried to deny, avoid or conceal. Many believed that the institutions had robbed art of its human vitality by presenting art works as static and discrete commodity objects; the revitalization of the body *as* art was a direct attempt to remedy that situation. The ritual-like procedures and conceptual experimentation of "performance art" led directly to its presentation in film and video, the only way this type of work could be seen by a wider audience. A major problem for both art criticism and public reception arose because documentation was becoming an art in its own right, an accreditation that made many people uncomfortable.

SITE WORK: As the architecture of space was being activated with, for example, installations of sound and light, artists were also pushing through walls to the outside world and manipulating actual landscapes. "Earthworks" can be seen as extended rituals of the body. Artists carved into or built on existing earth, rock or ice and even changed the course of natural waterways to create areas with an almost mystical quality. On an entirely different level, some of the work had a much more godless quality: Landscapes designed and populated by solitary individuals who, like mad scientists, conducted their research in the desert sun.

TECHNOLOGY: The advent of consumer film and, specifically, portable video equipment provided new tools for a creative population eager to utilize them. Hollywood and television production was always perceived as coming from some far away and magical place. Suddenly, affordable technology positioned many artists in a place they'd only dreamed of: The Director's Chair. The early films of Andy Warhol must be emphasized as a precursor to artists' film and video of the following decade: His experiments contained the seeds that flowered into much of the material that followed. Of utmost importance to a majority of the work in this series was his use of the continuous take. This technique, unsuited to the demands of Hollywood narrative, distinguishes film and video made by artists from their entertainment industry counterparts. An unbroken (unedited) length of celluloid or videotape was the chosen format for most of the artists represented here. It was the preferred method for transferring the "real time" experience of performance. (Warhol, of course, could go crazy in the editing room when needed). In addition, the temporal experience of film and video is in direct opposition to the static perception of the timeless, classical art object.

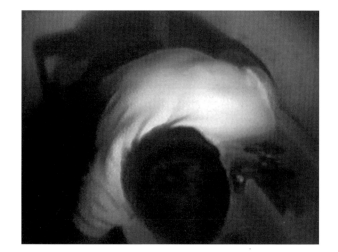

THE ARTISTS IN THIS SERIES, WITH SOME EXCEPTIONS, USED FILM AND VIDEO AS AN ENTERPRISE peripheral to their main body of work; the experimental film-makers working at the same time used film as their primary medium. In many examples, the artists were self-taught or "amateur," allowing for a more personal and direct revelation. Artists normally associated with media of a more "serious" or accepted stature are shown as casual or goofing off and inadvertently disclosing something closer to their true selves. The power and significance of this selection resides in the windows opened on the personalities who built the bodies of work. It reveals the people behind Benjamin's "mask."

CHRIS BURDEN: The work of performance artist and sculptor Chris Burden introduces a basic problem in experiencing this type of work: Where does the "art" reside? Is it in the film or video material or in some prior physical state of performance? In Burden's case, the title of his film on tape *Documentation of Selected Works* perhaps answers the question. Certain acts–in Burden's case certain notorious acts–are mythologically situated in art history. We hear about them; we

circulate what we hear about them; they become legendary: "Chris Burden crucified himself on a Volkswagen," or "Chris Burden fired shots at passing airplanes." Clearly, the transcendence of acceptable limits of social–never mind *artistic*–conduct was the aim; danger–to self and others–was his medium. The potency, perhaps terror, of the moment was the art incarnate. Watching the events from the safety granted by film and video is of enormous historical interest but nonetheless denatured, distanced, safe. In *Velvet Water* (1974), we watch helplessly as Burden repeatedly tries to breathe water from a sink. In retrospect, the compilation's moment of greatest signification comes during the introductory remarks rather than the documented acts themselves: The face of Burden outlining his work with focused sobriety, a concentration that barely hints at the havoc bubbling below the surface. At the end of the seventies and continuing to the present day, Burden began removing his actual presence from the work but continued to deal with near and present dangers, risks caught in stasis–conceptualized, sculptural–like swords in stone (e.g. *Medusa's Head*, 1990). Rather than dealing with the legend of the artist exploring the precipice, his subject broadened into historical palpability: Nuclear submarines, Vietnamese casualties of the Vietnam War, abuses both of authority and nature. The cult mythology of a dangerous artist has been replaced with the cult of destruction which permeates our planet. Perhaps, in Burden's mind, that isn't a shift at all. The form, however, has left the realm of documented art ritual–the past body–and entered the material of sculpture and the present world.

DENNIS OPPENHEIM: The passage from performance to sculpture runs a twisted course through the work of Dennis Oppenheim. According to him, even his own large-scale installations can be seen as a form of documentation. As he said in a recent interview, "Another related problem in approaching the artmaking process is the problem of entropy. If your beginning point is cerebral, the act of making some-

Chris Burden | *Medusa's Head* | 1990 | mixed media | 168 x 168 x 168 in. | Courtesy Gagosian Gallery | New York

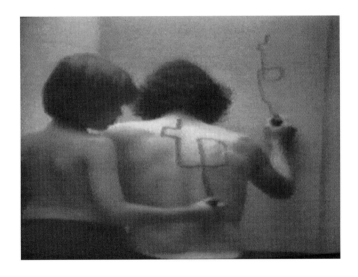

thing physical is often working toward a slow cooling down. That is, the art object becomes distanced from the mental temperatures that instigated it."[2] Faced with the cold residue or debris of a hot mental event, we pick up the pieces like detectives at a crime scene. The metaphor of physical material as temporary housing for the artist's idea (process) is also applicable to Oppenheim's film and video work. The permeability of barriers, mental material passing through one state into the next with the subsequent modifications imposed, is a recurring theme: "Piece after piece is about trying to push through a sort of envelope or membrane."[3] In the film on tape *Two Stage Transfer Drawing (Retreating to a Past State)* (1971), the artist draws on his son's back as his son transfers the form he feels onto a wall in front; Oppenheim senior connects with and through his own genetic material to produce the slightly altered drawing. A transcription has been made through and filtered by his own flesh and blood. Reversing the procedure Oppenheim junior draws on and "through" his father's back, his creative expression passing through the genetic possibilities of his own future. The phrase, "We're all turning into our parents," looses a screw. Sometimes the transfer is incomplete and we're left with images of the impermeable. In the 5-minute film on tape *Air Pressure (Hand)* (1971), a human hand is under attack by an invisible force (an off screen air pump). As the skin undulates over the skeletal armature, the commonest of objects is made uncannily strange, unfamiliar, grotesque. Nonetheless the membrane holds. The transfer, to some degree, is incomplete. This kind of thwarted passage is a recurrent Oppenheim theme. In the same year, he built the *Color Application for Chandra* installation. Projecting colors with their simultaneous audio names, he taught his daughter the correct correspondence between word and image. An audiotape of her voice naming the colors was installed in a similar situation with a parrot in a gallery; the bird learned to mimic the sounds but could not make the correct visual correlation. A transfer formula is reformulated with a broken element: The bird doesn't get it. In the Piranesian construct of Oppenheim's universe, he can, when he wants to, position his audience in the bird position.

Dennis Oppenheim | *Two Stage Transfer Drawing (Advancing to a Future State)* | 1971 | film on tape | Courtesy Electronic Arts Intermix | New York

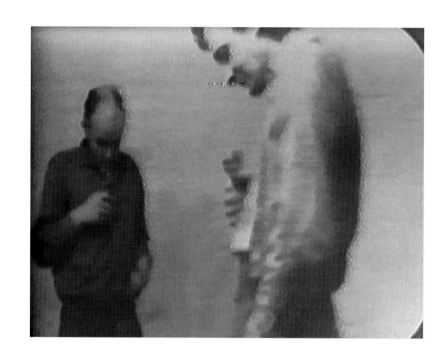

Dan Graham | *Past Future Split Attention* | 1972 | video | Courtesy Electronic Arts Intermix | New York

DAN GRAHAM: Dan Graham's videotaped performance piece *Past Future Split Attention* (1972) is also an exercise in the permeability of boundaries, this time in the social sphere. In a published transcript his premise reads: "Two people who know each other are in the same space. While one person predicts continuously the other person's behavior, the other person recounts (by memory) the other's past behavior." The performance gradually evolves from two separate monologues into an oscillating interplay reminiscent of a two-headed psychiatrist. As speaker A talks about events in speaker B's past, the focus can move quickly into the almost present: "You haven't so far looked me in the eyes." "You will notice that I will be looking at you for some time now." Forced to keep one ear on the other's statements they must also keep up their separate verbalized trains of thought. The push and pull of past knowledge and predictable future behavior creates a state akin to great jazz improvisation where performers must structure themselves by the rules of listening. More importantly, for the piece to work the performers must "know each other"; this introduces a cornerstone of Graham's projects then and now. When the viewer brings personal information into the performance arena there is an interplay of public and private spheres. Graham began developing this approach in the mid sixties with what he called his "first conceptual art," i.e., the placing of "ads" in popular magazines. Realizing that "The advertisement makes *public*–publicizes–a *private* need and, as a consequence, shifts categories of this relation," Graham plays on the traditional artist/venue/audience structure by eliminating (becoming) the middleman.[4] In a curious twist, his architectural work is a subtle repositioning of the space he originally wished to "short circuit." By designing his own areas–parks, atriums, and glass pavilions–he provides "public" space, designated sites for public interplay blended with and carefully masking complex private support structures.

RICHARD SERRA: Richard Serra's *Boomerang* (1974) travels a course similar to Graham's video above. In the former, artist Nancy Holt is attached to a tape-loop headphone circuit, a device which causes a delay in her words as they are fed back to her. (The content is her description of how the procedure feels.) The mode of concentration required by Graham's "Split" performers is

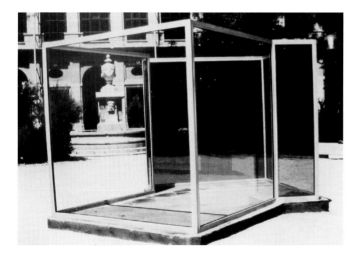

reduced to a single subject thrown into disjointed audio perception of and with herself. Watching her facial expressions pass from bewildered to amused to bewildered, we can literally see what Serra calls a "process as it is being formulated."[5]

It should come as no surprise that access to a medium designed for broadening communication and information (television via video) would not only be immediately recognized as manipulative, but quickly seized upon by artists to reverse the very process. A case in point is Serra's video *Television Delivers People* (1973). As ironic muzak spills from the soundtrack, a video-generated text of commodity critique scrolls by. According to Serra, the words were compiled from a variety of papers given at a New York University symposium; sentences were extracted and recombined as necessary. Examples include: "There is no such thing as mass media in the United States except for television. Mass media means that a medium can deliver masses of people. Commercial television delivers twenty million people a minute... You are the product of T.V."

Serra has explicitly denied the comparability of filmic and sculptural space. His short film, *Frame* (1969), using a sequence of measurement demonstrations, clearly shows TV-screen reality distorting basic geometries; a rectangle viewed from a side angle will appear as a trapezoid although in real space it's still a rectangle. "That is not to say that you can't talk about languages that people share, languages in different material manifestations. But to say that an experience of sculpture can be similar to or influenced by the illusion of film–I've always thought that was nonsense."[6] For Serra, film and video have their place–a site specificity of a different stripe–but true sculptural power, i.e., the ability to *activate* spaces public, corporate and beyond, is achieved through the sheer presence of Cor-Ten steel.

BRUCE NAUMAN: In Nauman's *Lip Sync* (1969), the video image of an upside down mouth continuously repeating the words "lip-sync" as it phases in and out of sync with its own sound track, creates a different type of perceptual havoc. As with the majority of his video works, and in concert with the written and neon word pieces, Nauman uses repetition to the point of rupture: The commonplace is no longer what it seems, as meaning collapses and folds in on itself. The visual aspect

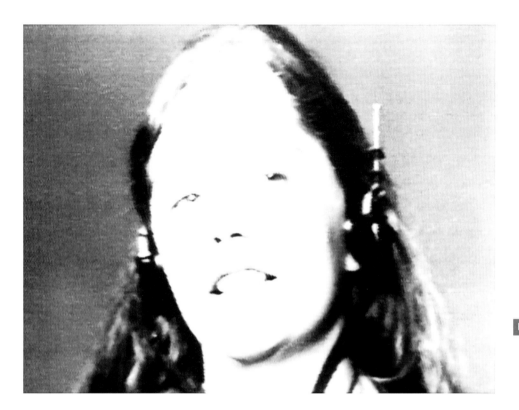

Richard Serra *Boomerang* | 1974 | video | Courtesy Video Data Bank | Chicago

Bruce Nauman *Lip Sync* | 1969 | video | Courtesy Video Data Bank | Chicago

The Exodus From ...

Keith Sonnier *Animation I* 1974 video Courtesy the Artist

must be emphasized: Staring at the mouth's position in the frame, the viewer will attempt to correct for disorientation. As the image morphs in mental recalibration, the chin seems to take on the form of a nose and vice-versa. Nauman's films and videos reinforce his overall program. They capture various "activities" performed in the studio that constitute, according to Nauman, the piece itself. (There is a metaphoric link between film and video and his use of body casts as well: "Impressions" of light on film or tape capture bodies no longer present.) Realizing that staring at a word or image long enough reduces it to gibberish, he takes the process one step further: If you stare at the construct of the self–the ultimate juncture of bodies and words–its meaning falls away as well.

KEITH SONNIER: Although Serra prefers formal separation of film and video from sculpture, Keith Sonnier opts for a symbiotic connection with his assorted works: Silkscreened images of abstract antenna, sculptural installations that can sometimes send and receive static amidst their broadcasts, light and hardware configurations that can be used for video backdrops or can stand as sculpture in their own right, and single-channel video. The act of transmission and reception–Sonnier's primary metaphor–is explored in forms ranging from binary electronics to transcultural relays. In his film on tape *TV Hybrid I* (1971), a vertical split screen (a device that may have been influenced by Warhol's *The Chelsea Girls*, 1966, a film Sonnier admires) includes images of people counting, an experimental dance involving a large sheet of fabric, random sampling from old TV movies, and a woman in a shower. When two people appear side by side, the screen design paradoxically keeps them apart and binds them together with its imaginary line, not unlike the act of telecommunication. *Animation I* (1974) intensifies the form by adding multiple exposure effects (video silkscreen) and news events. The result is reminiscent of the "image overload" culture now exemplified by both rock video and digital sampling technology; however, rather than manipulating the viewer, Sonnier's animation produces a diffused and disorienting effect. Similar sensations occur when faced with the diagrammatic glyphs of Sonnier's neon sculpture. Objects with an obvious internal logic tease us with semblances of meaning; we can construct temporary resting places (interpretations) but they seem tenuous as the antennae reverse polarity and become shields.

JOHN BALDESSARI: In an artist's hand, linguistic systems turn to language games as the play of meaning turns visual. In following a tradition of modern art that freely borrowed images (collage) and objects (assemblage), artists of the sixties (in a Duchampian renaissance) turned to conceptual appropriation. Borrowing from systems supposedly outside the aesthetic domain (science, law, business, etc.), they coopted structures of meaning as pliable media. John Baldessari's work is a prime example. Initially a painter, he began applying definitions and instructional text to canvas in the second half of the sixties. Paintings such as *Pure Beauty* (1967-68) or *This Is Not To Be Looked At* (1968) (with a photo emulsioned image of *Artforum* magazine) are typical examples. They also prefigure concerns that carry through to his video compilation *The Way We Do Art Now and Other Sacred Tales* (1973) in which commanding, pointing, and other activities of questionable overall merit address conceptions of rule making and transfer, properties gleaned from the form of activity rather than the utility of its content. Film and video, with their temporal succession of frames, are natural territories for Baldessari whose ordering procedures borrow the techniques of serialization, montage and visual linearity. The signature colored dots that typically cover the faces of the people in his photographs (a large percentage of which are movie stills) are static

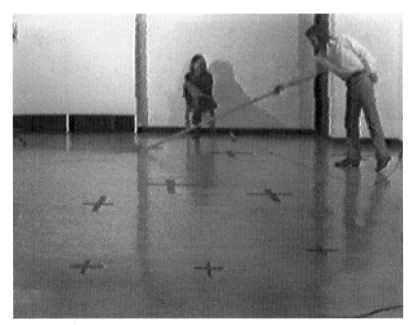

John Baldessari | *The Way We Do Art Now and Other Sacred Tales*
1973 | video | Courtesy Electronic Arts Intermix | New York

John Baldessari *Bloody Sundae* 1987 black-and-white photographs with vinyl paint mounted on board | Private Collection | Switzerland

forms of editing, as are all of the cropping procedures. The overall tone of *The Way We Do Art Now* has the unmistakable feel of an instructional video.

LAWRENCE WEINER: The manipulation of found images can be read as a rarefaction in the imagery of art: We have enough to work with, who would bother, or have the audacity, to make more? Lawrence Weiner pushes the envelope by applying his art–a bare bones formula of ordinary language–directly to the wall. Who needs to make imagery at all? Weiner's various video titles could just as easily appear in his "installation" art. Just imagine them clearly printed directly on a gallery wall: *To and Fro/Fro and To* or *Shifted from Side to Side* or *Nickel & Sweat & Copper Mixed Upon the Ground*. The last was an actual piece installed at the Philadelphia Museum of Art, December 1994. The simplified language and the corollary simplified (literal) movements of the videos refer, according to Weiner, not to a revolutionary conception of the art practice (the "Shifted" video shows the artist shifting a pack of cigarettes back and forth), but pre-modern sensibilities of craftsmanship that carry through to the present day. "It's a very simple process," remarks Weiner. "It's the same exact process artists have been using for their entire existence. They see something, they try to represent it in some way, not illustrate it, but represent it in some way–then they clean it up a little bit and show their virtuosity, and present it. It's classic art making. It just doesn't look like it."[7] Evidently Weiner's studio functions like any other: A procedure is inspired,

| Lawrence Weiner | *Iron Water Wood Stone . . .* | 1990 |
| wall installation | Courtesy Marian Goodman Gallery | New York |

IRON WATER WOOD + STONE

(CORRODED CUT & CARVED)

Lawrence Weiner *Shifted From Side to Side* 1972 video Courtesy Video Data Bank Chicago

related materials are brought in for trial and error, and adjustments are made. In the end, the "cleaning up" process has distilled the materials to words, which are then transported to the exhibition space.

VITO ACCONCI: Vito Acconci's videos capture discrete actions which the artist performs for the camera: "Biting myself: Biting as much of my body as I can reach. Applying printers' ink to the bites; stamping bite prints on various surfaces"; "Running in place for two hours; developing a heavy sweat; Leaning back against the wall; moving around against the wall–the sweat reacts with the paint, the paint spots my body";[8] "The goal of my activity is the production of seed–the scattering of seed throughout the underground area. (My aim is to concentrate on my goal, to be totally enclosed within my goal.) The means to this goal is private sexual activity."[9] At first Acconci's approach to the notion of the creative process seems to exist in opposition to ideas like Weiner's "classic art making" mentioned above, but he is applying the same basic principles (to clearly different ends). Commenting on a piece where he pulled out the hairs surrounding his navel, Acconci remarked, "I can think of this as a kind of cleansing, opening up new ground."[10]

Theme Song, a solo video piece from 1973, is quintessential Acconci. Lying on his living room floor, his face up close and all too personal with the camera, Acconci launches into a hypnotic smooth talking onslaught. Loosely improvised off a pop song soundtrack, his monologue is a barrage of meta-pick-up lines: "You don't want me to stay alone. You need it as much as I do. Whenever you're ready I'm ready to wrap myself around you," etc. The effect is invasive, intrusive; watching the video with an audience will help to dispel this; watch it alone and you feel like he's watching you. Big Brother has a hard on. In *Shoot* (1974), Acconci prances maniacally, making childlike war noises; the lights are flicked on and off as he babbles on, "I'm an American. I can't help it," and "I really do like Coca Cola; I have to have it." At one point he exposes his "fighter plane." The energy necessary to maintain the level of "I can do anything I want" hysteria falters occasionally: "I have an Italian name, a background, a culture. I don't have to be American at all." Needless to say, it is a short-lived sentiment. Both pieces are driven by the types of obsession and focus that characterize the majority of his work from the late sixties and early seventies. Forms of

Vito Acconci *Theme Song* | 1973 | video | Courtesy Electronic Arts Intermix | New York

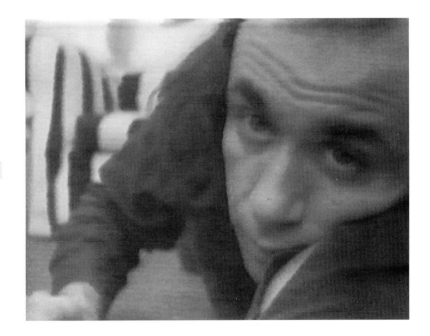

seductive S&M turn into exploratory probes, techniques for testing the new domain as *the object* becomes *the body*. Acconci's body eventually disappears from his art and is replaced by surrogate structures: Houses, automobiles, bicycles, etc. The development parallels the strategy we saw with Dan Graham above: Initial ideas of performative operations pave the way for the architectural structures to house them. In 1990-91, Acconci created the *Adjustable Wall Bra* installations, gallery sized steel and plaster brassieres (with internal seating, sound and lights). A garment representing female anatomy is converted into shelter; seduction masquerades as creature comfort. As his manipulation of scale shifts, yet again, the idea extends into models for exterior public park projects: The *Adjustable Ground Bra*. If he were to have things his way, Acconci would wrap his "body" around all of us.

PAUL McCARTHY: Paul McCarthy started his career as a painter and has remained fixated on the medium to the present day (*Painter* was the title of a recent video installation exhibited in The Museum of Modern Art's *Projects* gallery, Summer 1995.) His continuous puns on abstract expressionism and action painting include the literal identification of the body as medium, as demonstrated in his video *Painting Face Down* (1972). Using his face as a brush, he slowly crawls

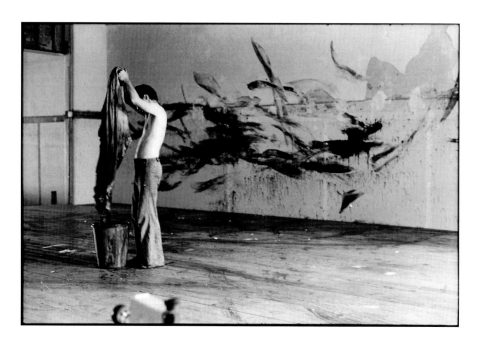

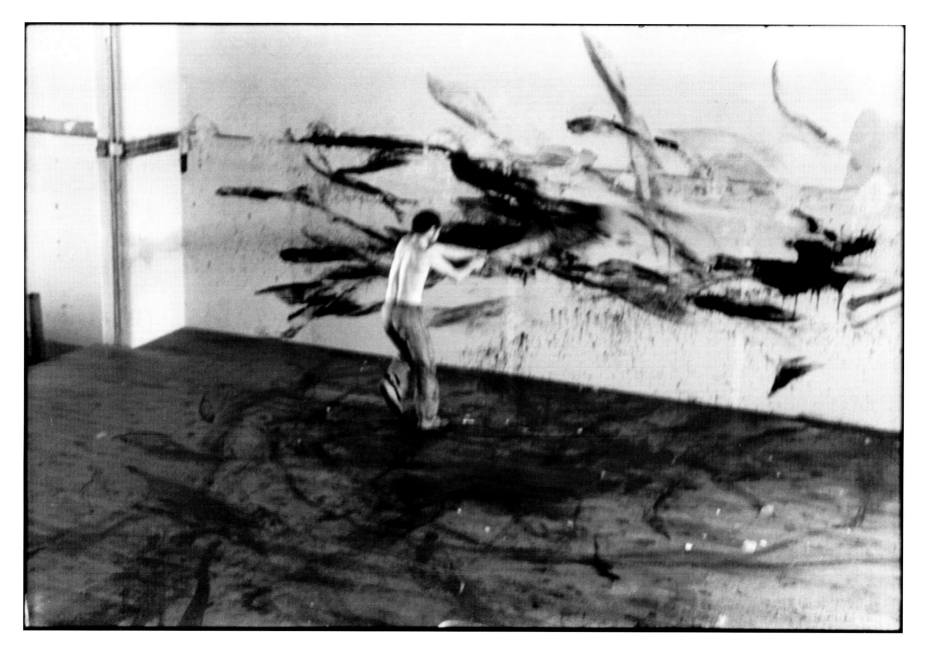

Paul McCarthy | *Whipping the Wall with Paint* | 1975 | video | Courtesy the Artist

Paul McCarthy | *Whipping the Wall with Paint* | 1975 | video | Courtesy the Artist

across a cellar floor leaving a sluglike paint trail. In *Whipping the Wall with Paint* (1975) the demonic dervish artist spins and flails in a post-Pollock frenzy. Over the years, McCarthy has parodied ideas of the heroic and intuitively expressive gesture, making them viscerally obscene through the use of his signature materials–ketchup, mayonnaise and his own genitalia. He often conceals his face with masks, creating characters who mirror the singular expression available to them. (Imagine a graduate studies program run by the cast of *The Texas Chainsaw Massacre*.) In *Experimental Dancer* (1975), a naked McCarthy–rubber mask on face and male member tucked away between his thighs–performs a repetitive stomping dance with his own panting gibberish accompaniment. It is oddly reminiscent of tribal dance patterns where the performers move in a uniform up/down pattern to demonstrate sexual prowess. It also recalls the repetitions of Nauman and the subsequent breakdown in the way meaning is conveyed. In a subset of performance tropes which resemble genetically mutated instructional video, McCarthy plays the role of "teacher," a part he also practices in real life. When confronted with an example of the artist's "lectures," the audience/class often responds with disbelief, shock and disgust. Conundrum: If, according to Nauman, "The True Artist Helps the World By Revealing Mystic Truths," how are we to position one who traffics in disbelief?

WILLIAM WEGMAN: Absurdity has a way of temporarily breaking through the veneer of social life (customs, manners, etiquette) to reveal what's underneath. William Wegman's jokes, the tricks he plays on his dogs (and on us), or the tricks he plays on himself, utilize that same principle. In his video *Duet* (1975), two dogs have fixed their sight lines on an off-screen object. As it moves, their heads track like Siamese radar. At the tape's conclusion, the hand-held tennis ball enters the frame and eclipses the lens. An attentive audience has become the content, as "attention," as such, becomes ridiculous. It is hard not to read the dogs as stand-ins for the art audience and Wegman as the master craftsman, orchestrating response. (Or are the dogs stand-ins for Wegman, and the activity a depiction of his own ability to fixate obsessively on absurdities?) In any event, the real substance seems to reside in disposability, the unpretentious lack of poise (pose) that makes the project

human. True to the nature of humor, we must accept the fact that we're dealing with pretty dumb stuff. (In one ultrashort untitled piece, Wegman blows a tiny object attached to a string out of his nose; it swings away, then back as he catches it with his mouth.) In this way Wegman is the predecessor to a whole range of work prevalent in the nineties: Abject art, the pathetic aesthetic, and other forms delving into honest exposures of frailty, impermanence and self-deprecating humor.

EDWARD RUSCHA: In 1993, Edward Ruscha received a commission from *Artforum* magazine for its thirtieth anniversary. Using wood letters and a gentle misting of red spray-paint on raw canvas, his message read: "Etc. Etc." A celebration of three decades was encapsulated into a one-liner distillation of critical redundancy (the editors put the painting on their cover). With a modicum of effort, Ruscha turned an artworld institution into not only a cosmic joke, but the very vehicle for that joke's expression. His paintings have always discretely functioned the same way: By calling into question their own status, they implicate the structure that placed them there.

William Wegman | *Man Ray, Man Ray* | video | 1978 | Courtesy Electronic Arts Intermix | New York

As a quintessential West Coast artist Ruscha is a natural for the cinematic apparatus. Indeed, of all the films in this series, the lush color imagery of *Premium* (1970) most closely resembles the visual language of "The Movies" as opposed to their more sober relative "Art." (Where else would we find a cameo by Tommy Smothers or the writing of TV pro Mason Williams?)

Ruscha's film follows actor/artist Larry Bell on a curiously constructed mission: After purchasing a variety of salad ingredients, he rents a sparse motel room and begins to build an elaborate vegetable sculpture on the bed between the sheets. He must now find a woman to complete his "salad." After luring a suitable participant to the motel, a displaced consummation occurs. He installs the woman into the salad and pours copious amounts of dressing on her. Bell states, in an afterthought, "I forgot the crackers." The camera follows him out the door, to a store; a box of Premium brand saltine crackers is displayed prominently for the camera as Bell proceeds to a different, more opulent location and consumes them, alone, in bed. The End. (Perhaps it's a critique of "process art.") Structurally, since we know the title, the graphic quality of the word "Premium" floats out of the filmic construct and anchors the piece, not unlike the words which hover over the landscape of Ruscha's paintings. Paintings like *Industrial Strength Sleep* (1989) or *Chain and Cable* (1987) posit poetic fragments, abstract advertising slogans that organize word and image into indelible meanings.

DAVID SALLE: David Salle's videos, *What's Cooking?* (1974) and *Reading Room* (1975), use techniques clearly present in his painting strategy. In the first, acquaintances are asked the title question as they prepare food. Salle then asks for a story of a death in their respective families. The everyday description of the insignificant occurrence is paired with the deeply meaningful. However, Salle directs the subject to remain continuously deadpan, so that the deep and the superficial are equated, and meaning becomes neutralized. In *Reading Room* a naked women runs through a variety of poses on a sofa. For each position she holds a different book and wears a different mask. Salle asks, "What are you reading?" She responds and we switch to the next tableau. The female body, an image that constantly appears in Salle's paintings, photographs and watercolors, becomes part of the seemingly random (interchangeable) flux of meaning. Needless to say,

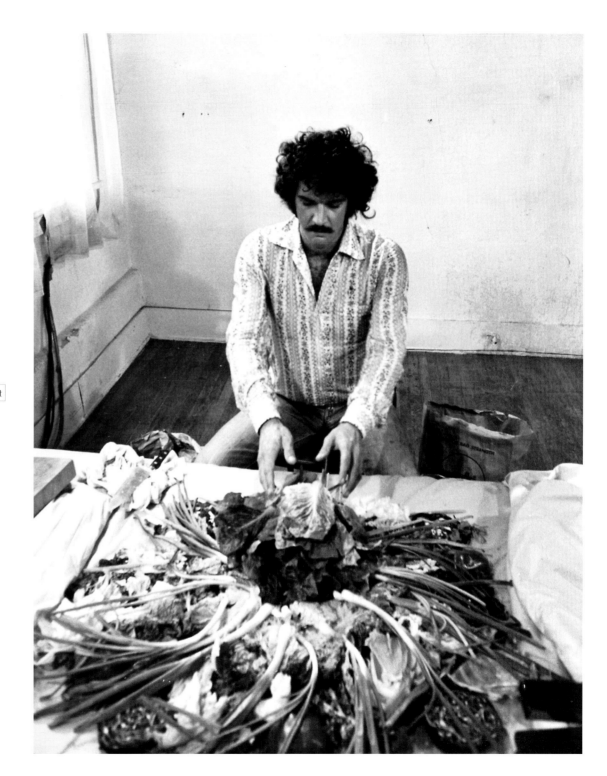

Edward Ruscha *Premium* film 1970 Courtesy the Artist

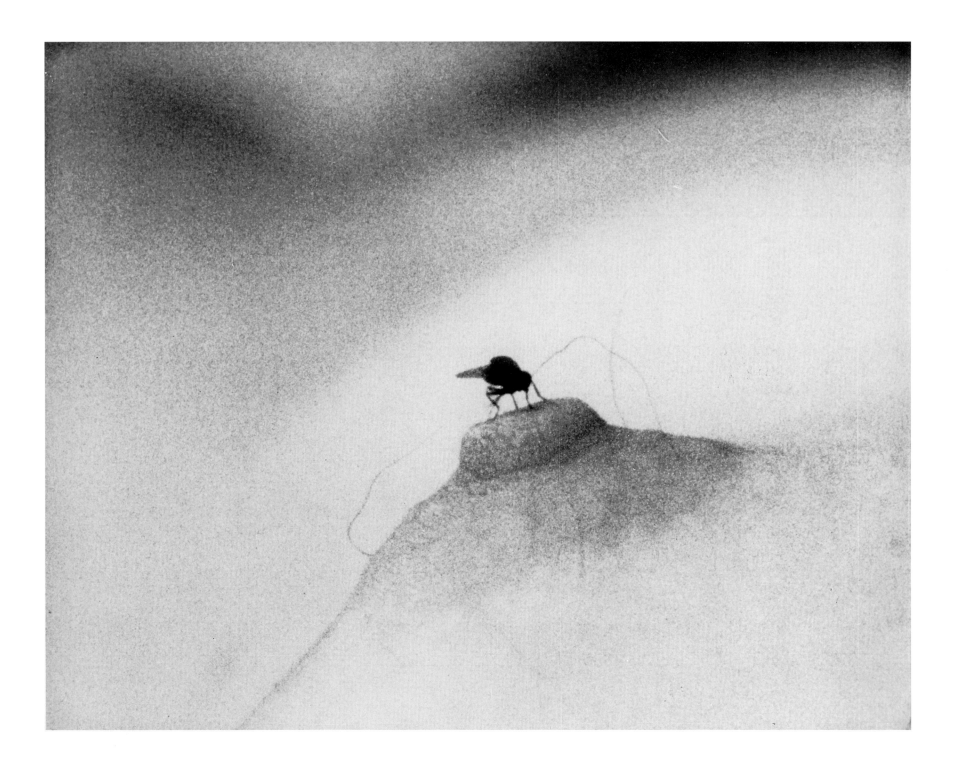

Salle is not presenting a critique of the objectification of the female body. His insistence on pornographic source material emerged, over time, as the only stabilized sign system his project could support. In his first Hollywood feature, *Search and Destroy* (1995), a lackluster individual trying to redeem himself by making a movie with a message ends up corrupted by the system.

YOKO ONO: Yoko Ono uses the female body as medium. In her film, *Fly* (1970), a naked woman sleeps undisturbed as a housefly descends upon her body. From the point of view of the insect, the body becomes monumental, transformed into a landscape with distinct areas and terrain, a planet in a deliriously rescaled solar system. Ono provides the fly sounds, vocal abstractions that adhere to the image and give it personality and character. The sounds are simultaneously childlike, erotic and filled with a sentient purposefulness: A flychild is concentrating hard on the various business it must attend to. The sounds are related to Ono's vocal work with the Plastic Ono Band (with John Lennon) and also recall similar explorations that Meredith Monk was conducting around the same time. Ono's work must be understood in terms of the Fluxus art movement, a loose federation of artists who would sometimes "follow" the anti-art, anti-formulations of their anti-leader George Maciunas. The radical politicization of the late sixties and early seventies (a reaction to the situation in Vietnam and the Civil Rights movement) turns into Ono's subject matter as she continually plays the role of conceptual peacemaker. *The Bed In* (1969), a performance in which Lennon and Ono held a "press conference" in bed, and *War is Over*, a Times Square billboard piece with the disclaimer "IF YOU WANT IT" are characteristic examples. The gentle sleeping giant of the fly's world can be seen as another, more esoteric representation of peace.

HANNAH WILKE: Hannah Wilke turned the tables on the exploitative use of the female body by a meta-exploitation of her own nakedness. Videos, photographs and performances turn the viewer into a self-reflective voyeur, queasily implicated in psychodramatic strategies. In *Through the Large Glass* (1976), Wilke takes a literal spin on Duchamp's *The Bride Stripped Bare By Her Bachelors, Even* (also known as *The Large Glass*) (1915-23) by removing her clothes as the camera views her through and also framed by Duchamp's masterpiece. In a fragmentary text from 1987,

Yoko Ono *Fly* | film | 1970 | Courtesy Lenono Photo Archive

Wilke writes, "Did Dr. Duchamp (MD) disguise with dignity or despair the destruction, degeneration, and denigration of the maimed model of mortality–Mother?" and "The Bride, separate from society, Having Given, also becomes a rape victim, whore fallen angel–A-Trophy in museum case, Eye Object, I object." (Her literary style should be seen in the context of her overall project; puns and other manipulative word games squeeze meaning into forms where the obvious becomes suspect.)

Wilke died of lymphoma in 1993, and in her last work, *Intra-Venus*, she confronted herself–and her audience–with the devastation of the disease. By explicit photographic documentation of her body's losing battle, Wilke turns the tables yet again as her form of visual narcissism (a radical empowerment) becomes an overt exposure of physical powerlessness. An ominous foreboding can be read into another fragment from 1987: "Involuntary motions of the mind, the mouth, the membranes: to cough, to sneeze, to breathe, to sleep, to cry, to shit, to come, to

Hannah Wilke *July 26, 1992/February 19, 1992, #4 from Intra-Venus* 1992-93 chromagenic supergloss each 71 1/2 x 47 1/2 in. Courtesy Ronald Feldman Fine Arts, Inc. New York

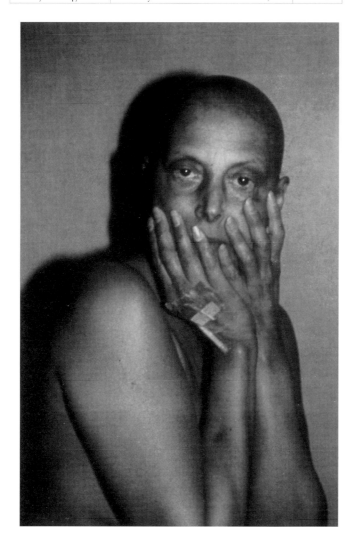

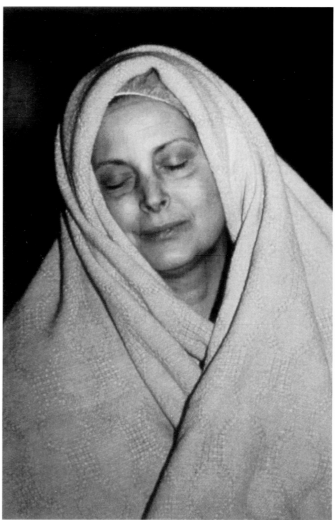

chew...Ah-choo. Instead of coffin, why not sneeze?" A Duchampian strategist to the end, she rebuilt *Why Not Sneeze, Rrose Selavy* (1921) but caged her own medicinal debris (prescription vials, spent syringes) in place of the master's marble cubes. An object has "trapped" and encapsulated a medical nightmare, a physical display of the art object's paradoxical triumph over corporeality. "Through the destruction and decay of the body one is rewarded with Heaven...."[11]

ROBERT KUSHNER: The naked *male* body is an element of Robert Kushner's *One Size Fits All* (1978), a "mocumentary" spin on the fashion show. Modeling his own costume creations, Kushner poses and exposes himself as his performance echoes strategies of P&D (pattern and decoration), a category of painting that Kushner exemplifies. Often employing fabric as an integral element, the P&D artists strive for an optic overall activation of the painting's surface, a decorative emphasis propelled by formalist strategy. The presence of the artist as model in Kushner's video exposes an element of camp that usually remains hidden beneath the painting's surface, an exposure of the playfulness that goes hand in hand with P&D's almost social planning dictates for environmental design: The world as their runway.

MARTHA ROSLER: In the same manner that Kushner appropriates the form of the fashion runway in *One Size Fits All*, Martha Rosler borrows cues from a TV cooking show in her video *Semiotics of the Kitchen* (1975). As she lists the tools of her "trade" (the role of housewife is thrown into quotation marks by Rosler's borderline violence), the armaments of the kitchen begin to take

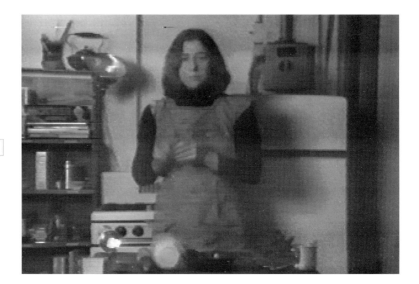

Martha Rosler *Semiotics of the Kitchen* | video | 1975 | Courtesy Electronic Arts Intermix | New York

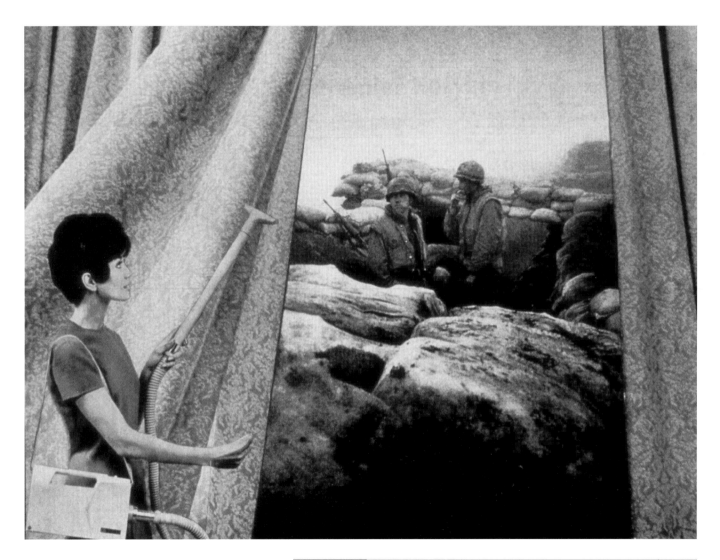

Martha Rosler *Cleaning the Drapes* from *Bringing the War Home: House Beautiful* 1969-72

photomontage printed as color photograph | 20 x 24 in. | Courtesy Jay Gorney Modern Art | New York

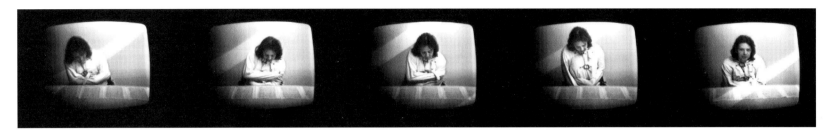

on an ominous undertone: Everyday objects become implements of oppression. Rosler is perhaps best known for her photomontage series, *Bringing the War Back Home: House Beautiful* (1967-72), in which the characteristically opulent splendor of glossy magazine-style home design is undermined by subtle graftings of Vietnam photojournalism. This series attacks with a double-edged sword: It's a condemnation of our involvement abroad as well as a stab at our skewed class/status system at "home." Editing harsh realities into advertising fantasy, Rosler plays a game of visual equivocation. Her work of this period is a precursor of art practices that come to full fruition in the eighties as commodity critique. The work, however, must be understood within the context of its time: Originally circulated through antiwar publications, they were not formally exhibited until 1991.

 ALLEN RUPPERSBERG: Five variations on the "documentary" format appear in works by Allen Ruppersberg, Ilene Segalove, Eleanor Antin, Nancy Graves and Nancy Holt. Ruppersberg delivers his video, *A Lecture on Houdini* (1973), wearing a straight jacket and seated at a table with his text spread out before him. He reads aloud of Houdini's obsession with "establishing physical contact with the world of the spirit" and is obviously aligning himself as master's apprentice (try as he will, he cannot free himself from the jacket). Life after death (mourning and melancholia) is a recurring theme in his work. In 1974 he made *The Portrait of Dorian Gray*, a hand-written copy of Oscar Wilde's entire text mounted on canvas; in both the book and Ruppersberg's project, the possibility for everlasting life is linked to the parallel degeneration of an art object.

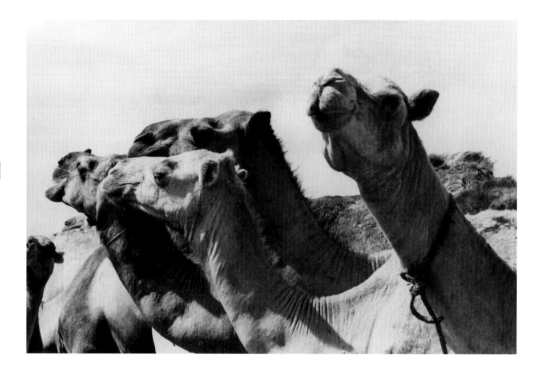

Nancy Graves *Isy Boukir* | 1971 | film | Courtesy the Artist

NANCY GRAVES: Sculptor Nancy Graves' color film *Isy Boukir* (1971) stars a large herd of camels. Parked beside a watering hole, they drink, chew, flick their tails and discuss the day's events. Some of Graves' earliest sculptures resemble camels. Well known for her large, multicolored organic abstractions of the eighties, her use of composition and rack focus techniques in *Isy Boukir* give the film a sculptural quality: As the lens moves through different planes of clarity, the experience is like exploring a three-dimensional object with repeated passes of the eye, discovering new aspects as it moves in closer. A nature film reveals the world as abstract art.

NANCY HOLT: Nancy Holt's *Pine Barrens* (1975) is another example of an artist's "nature film." Shot in a remote and desolate area in Southern New Jersey (with well seasoned locals providing voice–over commentary), it is also related to projects she worked on with her husband, Robert Smithson. The film travels through an endless terrain that is both nondescript and engrossing in its emptiness. One can imagine both artists loading up their cameras and taking off on

Nancy Graves | *Camel VI, VII & VIII* | 1968-69 | wood, steel burlap, polyurethane, animal skin, wax, oil paint | each c. 96 x 126 x 48 in.
Collection of National Gallery of Canada, Ottawa | *Camels VII & VIII* | Gift of Allan Bronfman | Montréal

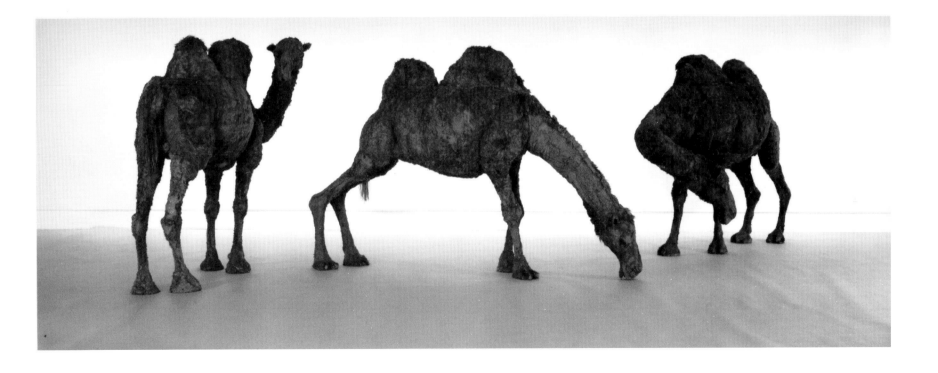

exploratory missions, looking for potential sites and "nonsites" (see SMITHSON below). It is an experience of land as an unfathomable quantity and quality, an endless material that frames human life as surely as it is framed by life: Space displaced. Holt can frame landscapes as well as the people within them, and even when there's nobody there, the image will always have an ambient aura, a form of nostalgia that's purified of sentimentality.

ILENE SEGALOVE: Ilene Segalove has described some of her videos as "pseudo-travelogues" or "pseudo-documentaries." In *The Mom Tapes* (1974-78) Segalove documents off-the-cuff versions of typical mother-daughter interplay: "Mom, I'm bored" or "Mom, I need a Toastmaster. Where can I get one?" etc. The banal, the everyday and the not-so-great were becoming acceptable forms of artworld subject matter. In a photomontage from 1975, Segalove mimics the poses of four historic figures (Louis Daguerre, Sir Issac Newton, Joan of Arc, and a Barbie doll). She titles the piece: *Close, But No Cigar*. With the advent of the first portable video machines, artists like Segalove exemplified a new wave in approach that preferred exploration on smaller, more personal levels. Deadpan self-effacement and autobiography are motifs that she shares with Eleanor Antin.

ELENOR ANTIN: Eleanor Antin repeatedly uses the alter ego in her performance and video work. In *Little Match Girl Ballet* (1975) she is almost herself as Eleanora Antinova, an aspiring ballerina daydreaming of being discovered by George Ballanchine. Since she has taught herself ballet from a book, she is unable to do anything but strike poses: A human sculpture performing in a pathos of ineptitude. Both Antin and Segalove are interested in the idea of revealing the self-portrait–the picture that is supposed to come closest to the artist's true inner life–as something that is, on an essential level, fabricated, a construct like any other.

LYNDA BENGLIS: Sculptor Lynda Benglis' *Female Sensibility* (1973), and her other video work from the same period deal, in part, with feminist issues generated by the camera itself. Is it possible to describe forms of technology as being either male or female? Talk of "the male gaze," a gender-specific psychological property, was extended into the fabric of culture and political power. Vision was said to be guided by a media-saturated environment that was both creating roles and

Nancy Holt *Pine Barrens* | 1975 | film | Courtesy the Artist

Ilene Segalove *The Mom Tapes* 1974-78 video Courtesy Video Data Bank Chicago

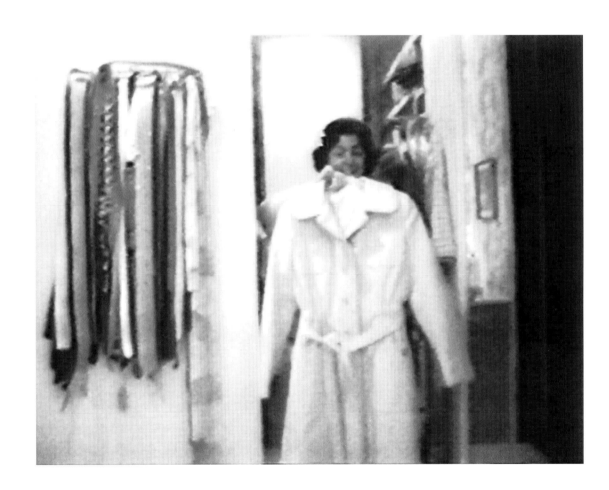

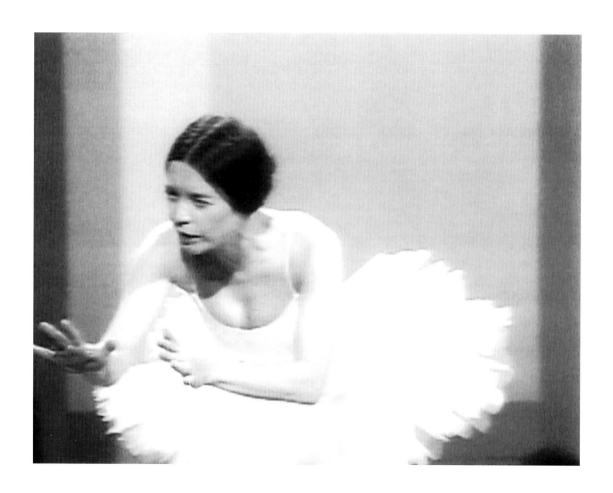

representations and reinforcing them at the same time. In the Benglis video, two women gaze at and caress each other. The "sensibility" is a cliché being undermined by the role play of lesbian lovers. The seductive act of voyeurism, in a way similar to Wilke, is pushed to a back burner as the viewer becomes conscious of his or her relationship with the camera. The tool that is supposed to record and retain the objective reality of things faithfully, starts to look a little suspicious and, perhaps, a little sinister.

ROBERT MORRIS: The career of Robert Morris has touched upon an incredible array of media. His silent black-and-white film *Wisconsin* (1970) is a loose derivation of his performance piece *Check* (1965). In the film, a large crowd of performers move about a rural landscape. The patterns of organization include line-ups, clustering, scattering (some of his sculpture are described as "scatter pieces"), falling, crawling, climbing on one another, pushing through each other, etc. The choreography can be seen in relation to the non-narrative everyday movement practices of John Cage and Merce Cunningham, which were distilled in the early sixties by the Judson Dance Theatre in New York. Other names associated with this nexus include Yvonne Rainer, Lucinda Childs, Trisha Brown, Ann Halprin, La Monte Young, Terry Riley, and others. The concept of the Judson Group that particularly intrigued Morris was "task-oriented" articulation of the body, choreography based on "found movements." (Think of it as a Duchampian dance form, a shift in focus that interrogates the hierarchy of high art--ballet and its related institutions--as it substituted the commonplace for virtuosity.) However, their paths soon diverged as Morris pursued a new direction. According to Maurice Berger, "The Judson Group's explorations of process were so intent on overturning the conventions and practices of modern dance that they became inner-directed, obsessed with the formal conventions of dance itself."[12]

ANDY WARHOL: Andy Warhol's first film was *Sleep* (1963). A study in both the motionless and the monumental (originally 5 hours and 20 minutes long), it paradoxically embraces minimalism and naturalism, the hyperformal and the realistic. (As a testament to the stamina necessary to sit through a complete screening, one can take solace in the fact that John Giorno, the sleeper him-

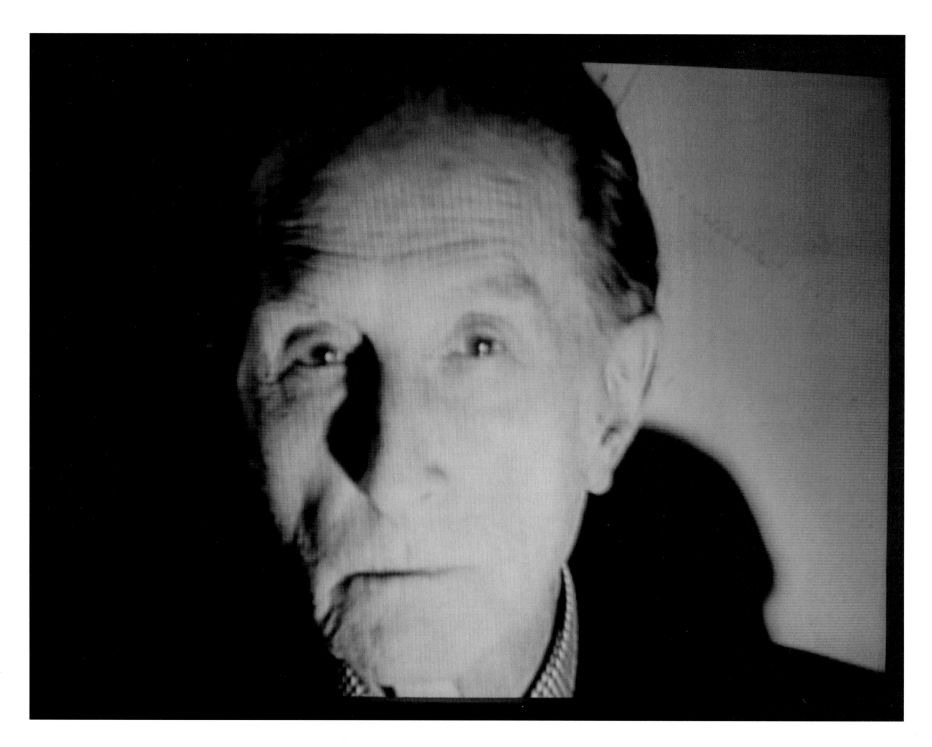

self, hasn't.) The singularity of this type of non-narrative focus is characteristic of the majority of Warhol's early films (*Eat*, *Kiss*, *Blow Job*, *Haircut (No. 1)*, etc.) and, bringing the process full circle, frames from the films (two from *Sleep* in particular) were blown up into silkscreens and printed onto plexiglass sheets supported by free-standing metal stands, not unlike a sculptural echo of the celluloid itself.

As heir apparent to the throne of the readymade, it is fitting and appropriate that Warhol also be represented here by his *Screen Test: Marcel Duchamp* (1966). As the image of Duchamp returns from the early sixties to lock us in his gaze, we are brought face to face with a magical aspect of the medium: The dead are brought back to life. As the arresting sensation twists tighter, we realize we see Duchamp through Warhol's eyes.

From 1964 to 1966 Warhol shot over 500 *Screen Tests*. Each ran the duration of a single, continuous, 100-foot roll of 16mm film. Subjects (various passers-by to the Factory) could pose, pout, or just sit and stare until their film ran out. Asked why he chose to explore the medium, he expressed his love for the mechanism: "You just turn on the camera and walk away."[13]

GORDON MATTA-CLARK: The majority of Gordon Matta-Clark's work no longer exists. This is not surprising since he chose as his signature medium buildings scheduled for demolition. Manipulating the site prior to the arrival of the wrecking ball, Matta-Clark would slice into, split open, and remove entire zones of architecture. The buildings were "marked" by incisions, soon-to-be-destroyed manipulations that now exist only as photographic reproductions. He places us in a vertiginous position between voids (those created within the "frame" of the now absent building) and leaves us hanging in negative space. Yet, he explains, "You read through the negative space to the edges of the building...the edge is what I work through, try to preserve, spend this energy to complete."

Photographs of Matta-Clark's generic suburban house, split down its middle, are instantly recognizable to anyone familiar with his art. The documented work-in-progress, captured on motion picture film, is not. He was constantly playing with ideas of movement through space (the photomontages were "an attempt to try and capture the 'all around' experience of the piece... an

| Andy Warhol | *Screen Test: Marcel Duchamp* | 1966 | film |
| Courtesy The Andy Warhol Foundation for the Visual Arts, Inc. | New York |

approximation of this kind of ambulatory 'getting to know' what the space was about").[14] But a hand-held roaming camera, shifting through various planes of perspective and focus, brings to life aspects a photograph can only hint at: Matta-Clark leads us through the work, calling attention to the details and movements *he* finds significant. Still, the ability of the photomontages to conjure the space between the actual images, by letting the viewer's imagination fill in the perceptual voids, cannot be underestimated.

Key influences in Matta-Clark's development were his initial training as an architect and the work of his father, the great surrealist painter, Matta (Roberto Matta Echaurren). The imagery of Matta senior (especially the illusionistic slices in surreal space and the sensation of infinite interior horizons) are so contiguous with Matta-Clark that it is possible to argue for an overall familial project, a double-helix spiralling back and forth through art history. When they diverge, they do so in complementary ways, with the father creating images of hybrid organic/machines that could float comfortably in the architectural vortices created by the son.

ROBERT SMITHSON: Robert Smithson is the creator of the "Nonsite," a structural displacement of material–rocks and minerals–from its original source to an art world location, with accompanying documentation: Maps, aerial photographs, statements, etc. The establishment of a "dialectic" interplay between the original location and the displaced sculptural form develops through three periods in Smithson's work. The initial site/nonsite distinction, the second phase, where the original site (earthwork) is a visitable part of the overall work and the third period, the proposed "reclamation" projects where industrial sites were to be converted into areas almost totemic in quality. For Smithson, however, the idea of a spiritual response is inappropriate: "I think things just change from one situation to the next, there's really no return."[15] In place of transcendence, Smithson posits the commandment of entropy in an idea for an imaginary film:

> I should now like to prove the irreversibility of eternity by using a *jejune*
> experiment for proving entropy. Picture in your mind's eye [a] sandbox
> divided in half with black sand on one side and white sand on the other.

Gordon Matta-Clark *Splitting* 1974 film on tape Courtesy Electronic Arts Intermix New York

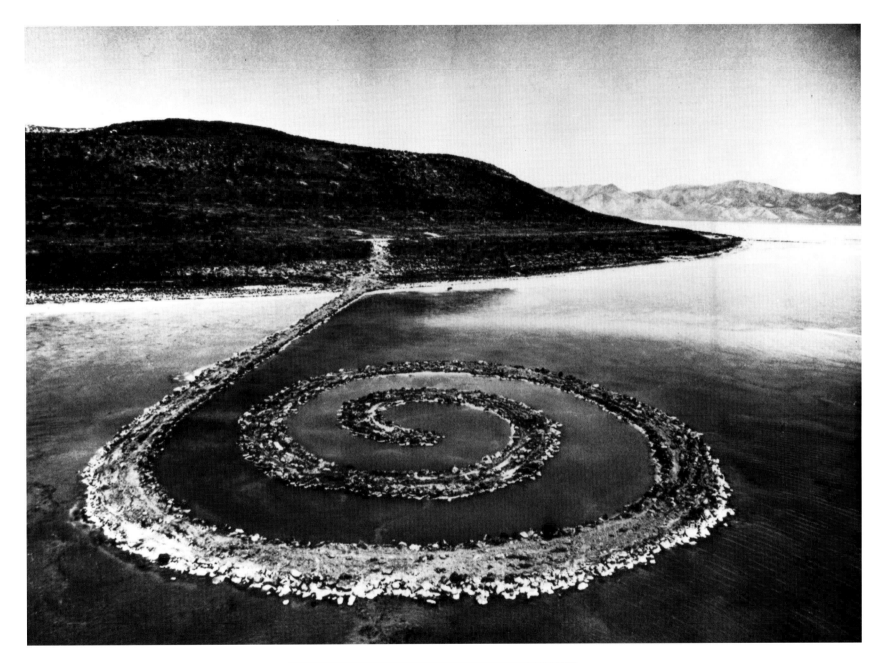

Robert Smithson *Spiral Jetty* 1970 film Courtesy Nancy Holt

We take a child and have him run hundreds of times clockwise in the box until the sand gets mixed and begins to turn grey; after that we have him run counter-clockwise, but the result will not be a restoration of the original division but a greater degree of greyness and an increase of entropy.

Of course, if we filmed such an experiment we could prove the reversibility of eternity by showing the film backwards, but then sooner or later the film itself would crumble or get lost and enter the state of irreversibility. Somehow this suggests the cinema offers an illusive or temporary escape from physical dissolution. The false immortality of the film gives the viewer an illusion of control over eternity–but the 'superstars' are fading.[15]

The relevance of the above quotation to Smithson's film, *Spiral Jetty* (1970) cannot be over-emphasized. Near abandoned oil rigs, in the desolation of Utah's Great Salt Lake, Smithson moved 6,650 tons of mud, rock, and salt crystal into an offshore spiral pathway to nowhere. The film documents construction by adding eerie sound effects, images of dinosaurs intercut with the earthmoving equipment, extensive aerial footage, and other quasi-scientific documentary procedures. Throughout, Smithson narrates in a voice that is equal parts dispassion and nostalgia. The film ends (in a site/nonsite parallel) with a poster-sized image of the jetty tacked to the wall over a film editing table.

Smithson frequently thought and spoke in film terms. Along with plans for a literally "underground" cinema (built in a cave or mine showing only a film documenting its own construction), he perceived the world as if it was composed of equipment in a high school A/V room:

> Noonday sunshine cinema-ized the site, turning the bridge and the river into an over-exposed *picture*. Photographing it with my Instamatic 400 was

Bas Jan Ader	*Farewell to a Friend Faraway*	1970	film
Courtesy Patrick Painter Editions		Bas Jan Ader Estate	
Hong Kong and Vancouver, British Columbia			

like photographing a photograph. The sun became a monstrous light bulb that projected a detached series of stills through my Instamatic into my eye. When I walked on the bridge, it was as though I was walking on an enormous photograph that was made of wood and steel, and underneath the river existed as an enormous movie film that showed nothing but a continuous blank.[16]

Or as he put it more succinctly, "I'm just interested in exploring the apparatus I'm being threaded through...."[17]

Bas Jan Ader: The Dutch conceptual artist Bas Jan Ader does not have a large body of work. Two contributing factors are his tragic early death at the age of 33 and the elusive and ephemeral quality of his work–generally performance-based installations–that now only exist in a handful of photographs. His films were deceptively simple, short, and poetic. A common theme was "falling," with Ader as gravity's subject. In the black-and-white film *Broken Fall (Organic)* (1971), Ader holds tightly to a tree branch suspended over water; when he falls in the film ends. In *Broken Fall (Geometric)* (1971), he teeters and then falls on a sawhorse. In *Nightfall* (1971) he drops rocks on a pair of lit lightbulbs at his feet and the light is extinguished by a "fall" into darkness. At one point he described himself as a "Fall Artist." Since he refused to explain his art or himself it is unclear if he was making a pun (a technique he favored) on the concept of "Fall Guy." It seems possible. Near the end of 1975, Ader embarked on the third stage of his conceptual piece *In Search of the Miraculous.* Climbing into a small boat he set sail, alone, to cross the Atlantic. The boat was recovered off the coast of Ireland. Ader's body was never found.

The memory of what is not may be better than the amnesia of what is.
Robert Smithson

Chris Chang, 1995 – For my grandparents

Notes

1. Walter Benjamin, *Reflections*, ed. Peter Demetz, trans. Edmund Japhrott (New York: Schocken Books), 1986, p. 81.

2. Interview with Alanna Heiss, *Dennis Oppenheim: Selected Works 1967-90* (New York: Institute for Contemporary Art and Harry N. Abrams, 1990), p. 162.

3. Ibid., p. 182.

4. Dan Graham, *For Publication* (New York: Marian Goodman Gallery, 1991, repr.), un.p.

5. "Early Video Art in the United States," compilation from Video Data Bank, Chicago, n.d.

6. "Richard Serra's Films: An Interview," with Annette Michelson and Clara Weyergraf, *October*, Fall 1979, p. 73.

7. From an interview with Ann Temkin and John Ravenal, Philadelphia Museum of Art brochure published in conjunction with Lawrence Weiner's installation, December 1994.

8. Germano Celant, "Dirty Acconci," *Artforum*, November 1980, pp. 77, 78.

9. Robert Pincus-Witten, *Artforum*, April 1972, p. 48.

10. Celant, p. 79.

11. *Hannah Wilke: A Retrospective*, ed. Thomas H. Kochheiser, essay by Joanna Frueh (Columbia, Moussori: University of Missouri Press, 1969), pp. 139-155.

12. Maurice Berger, Labyrinths: Robert Morris, Minimalism, and the 1960's (New York: Icon Editions, Harper & Row, 1989), p. 90.

13. From an interview in the documentary "Warhol: Portrait of an Artist", produced and directed by Kim Evans, London Weekend Television's "South Bank Show" co-produced with RM Arts, 1987.

14. Judith Russi Kirchener, "Non-Uments," *Artforum*, October 1985, pp. 103-108.

15. *Robert Smithson: Sculpture*, ed. Robert Hobbs (Ithaca, New York and London: Cornell Paperbacks/Cornell University Press, 1981), p. 94.

16. Ibid., p. 91.

17. Ibid., p. 35.

Film Programs

1. **ANDY WARHOL**, *Screen Test: Marcel Duchamp*, 1966, black-and-white, 3 minutes, silent

 HANNAH WILKE, *Through the Large Glass*, 1976, color, 9 minutes

 YOKO ONO, *Fly*, 1970, color, 25 minutes

 NANCY GRAVES, *Isy Boukir*, 1971, color, 16 minutes

 ANDY WARHOL, *Sleep*, 1963, black-and-white, 37 minutes (excerpt), silent

2. **YOKO ONO**, *Museum of Modern Art Show*, 1971, color, 7 minutes

 BAS JAN ADER, *Untitled (Tea Party)*, 1972, black-and-white, 1:40 minutes, silent

 BAS JAN ADER, *Primary Colours (Red, Yellow, and Blue Glasses)*, 1973, color, 26 minutes, silent

 BAS JAN ADER, *Broken Fall (Geometric)*, 1971, black-and-white, 1:50 minutes, silent

 BAS JAN ADER, *I'm Too Sad to Tell You*, 1971, black-and-white, 2:05 minutes, silent

 BAS JAN ADER, *Nightfall*, 1971, black-and-white, 5 minutes, silent

 BAS JAN ADER, *Farewell to a Friend Faraway*, 1970, black-and-white, 5 minutes, silent

 ROBERT MORRIS, *Wisconsin*, 1970, black-and-white, 15 minutes, silent

 EDWARD RUSCHA, *Premium*, 1970, color, 30 minutes

3. **NANCY HOLT AND ROBERT SMITHSON**, *Swamp*, 1971, color, 6 minutes

 NANCY HOLT, *Pine Barrens*, 1975, color, 31 minutes

 ROBERT SMITHSON, *Spiral Jetty*, 1970, color, 34:30 minutes

Video Programs *

1. **MARTHA ROSLER**, *Semiotics of the Kitchen*, 1975, black-and-white, 6 minutes

 DAVID SALLE, *What's Cooking*, 1974, black-and-white, 11:28 minutes

 LYNDA BENGLIS, *Female Sensibility*, 1973, color, 13 minutes

 HANNAH WILKE, *Hello Boys*, 1975, black-and-white, 12:30 minutes

 VITO ACCONCI, *Theme Song*, 1973, black-and-white, 33:15 minutes

2. **ILENE SEGALOVE**, *The Mom Tapes*, 1974-78, color, 27 minutes

 HANNAH WILKE, *Intercourse With*, 1977, black-and-white, 22 minutes

 ELEANOR ANTIN, *The Little Match Girl Ballet*, 1975, color, 27 minutes

3. **DAVID SALLE**, *Reading Room*, 1975, black-and-white, 6:42 minutes

 PAUL McCARTHY, *Experimental Dancer*, 1975, color, 5 minutes

 VITO ACCONCI, *Shoot*, 1974, color, 10:18 minutes

 ROBERT KUSHNER, *One Size Fits All*, 1978, color, 28 minutes

 GORDON MATTA-CLARK, *Clock Shower*, 1973, film on tape, color, 13:50 minutes, silent

 WILLIAM WEGMAN, *Gray Hairs*, 1976, black-and-white, 5:10 minutes

 WILLIAM WEGMAN, *Man Ray, Man Ray*, 1978, color, 5:23 minutes

 WILLIAM WEGMAN, Selected works, 1970-78

4. **LAWRENCE WEINER**, *To and Fro/Fro and To/And To and Fro/And Fro and To*, 1972, black-and-white, 1 minute

 LAWRENCE WEINER, *Shifted from Side to Side*, 1972, black-and-white, 1 minute

 LAWRENCE WEINER, *Broken Off*, 1971, black-and-white, 1:30 minutes

all works originally recorded on video unless otherwise noted

LAWRENCE WEINER, *Beached*, 1970, black-and-white, 2:30 minutes

DENNIS OPPENHEIM, *Two Stage Transfer Drawing (Advancing to a Future State)*, 1971, film on tape, color, 2:48 minutes, silent

DENNIS OPPENHEIM, *Two Stage Transfer Drawing (Retreating to a Past State)*, 1971, film on tape, color, 2:57 minutes, silent

PAUL MCCARTHY, *Painting Face Down--White Line*, 1972, black-and-white, 2 minutes

PAUL MCCARTHY, *Whipping the Wall with Paint*, 1975, black-and-white, 2 minutes

PAUL MCCARTHY, *Split*, 1974, black-and-white, 2:30 minutes

PAUL MCCARTHY, *Zippedy Doo Dance*, 1974, black-and-white, 1 minute

PAUL MCCARTHY, *Upside Down Spitting-Bat*, 1975, black-and-white, 4:30 minutes

JOHN BALDESSARI, *The Way We Do Art Now and Other Sacred Tales*, 1973, black-and-white, 28:28 minutes

ALLEN RUPPERSBERG, *A Lecture on Houdini*, 1973, black-and-white, 30 minutes

5. CHRIS BURDEN, *Documentation of Selected Works*, 1971-74, 1975, video and film on tape, black-and-white and color, 34:58 minutes

GORDON MATTA-CLARK, *Splitting*, 1974, film on tape, color, 10:50 minutes, silent

GORDON MATTA-CLARK, *Bingo X Ninths*, 1974, film on tape, color, 9:40 minutes, silent

DENNIS OPPENHEIM, *Brush*, 1973, film on tape, color, 4:56 minutes, silent

DENNIS OPPENHEIM, *I'm Falling*, 1972-73, film on tape, color, 1:48 minutes, silent

DENNIS OPPENHEIM, *Disappear*, 1972, film on tape, black-and-white, 5:57 minutes, silent

DENNIS OPPENHEIM, *Air Pressure (Hand)*, 1971, film on tape, color, 5:25 minutes, silent

DENNIS OPPENHEIM, Selected Works from the Aspen Projects:
 Identity Transfer, 1970, film on tape, black-and-white, 1 minute
 Rocked Hand, 1970, film on tape, color, 3:34 minutes
 Compression-Fern (Hand), 1970, film on tape, color, 5:46 minutes
 Glassed Hand, 1970, film on tape, color, 2:56 minutes

6. RICHARD SERRA AND CARLOTA FAY SCHOOLMAN, *Television Delivers People*, 1973, color, 6:23 minutes

KEITH SONNIER, *Animation I*, 1973, color, 13:24 minutes

KEITH SONNIER, *TV Hybrid I*, 1971, film on tape, color and black-and-white, 13 minutes

DAN GRAHAM, *Past Future Split Attention*, 1972, black-and-white, 17 minutes

RICHARD SERRA, *Boomerang*, 1974, color, 11 minutes

BRUCE NAUMAN, *Lip Sync*, 1969, black-and-white, 10 minutes (excerpt)

Angell, Callie. *The Films of Andy Warhol: Part II*. New York: Whitney Museum of American Art, 1994.

Antin, Eleanor. "Reading Ruscha," *Art in America* (November-December 1973), pp. 64-71.

Arn, Robert. "The Moving Eye...Nancy Graves Sculpture, Film, and Painting," *Artscanada* (Spring 1994), pp. 42-48.

Battcock, Gregory. "Celluloid Sculptors," *Art and Artists* (October 1971), pp. 24-27.

——————, ed. *The Art of Performance: A Critical Anthology*. New York: E. P. Dutton, 1984.

——————, ed. *The New American Cinema*. New York: E.P. Dutton, 1967.

——————, ed. *New Artists Video: A Critical Anthology*. New York: E.P. Dutton, 1978.

Benjamin, Walter. "The Work of Art in the Age of Mechanical Reproduction." *Illuminations*. New York: Schocken Books, 1969.

Bourdon, David. "What Develops When Painters Pick Up Cameras," *Village Voice*, (October 20, 1975).

Boyle, Deirdre. *Video Classics: A Guide for Video Art and Documentary Tapes*. Toronto, Canada: Art Metropole, 1979.

van Bruggen, Coosje. *Bruce Nauman*. New York: Rizzoli, 1988.

Buchloh, Benjamin. "Bilmographie Filme von Kunstlern 1960-1974," *Interfunktionen* (December 1975), p. 94.

——————. "Process Sculpture and Film in Richard Serra's Work," *Structures for Behaviors: New Sculptures by Robert Morris, David Rabinowitch, Richard Serra and George Trakas*. Toronto: Art Gallery of Ontario, 1978.

Carmean, E.A., Jr., ed. *The Sculpture of Nancy Graves*. New York: Hudson Hills, 1987.

Castelli/Sonnabend Tapes and Films, vol. 1. New York: Leo Castelli and Illeana Sonnabend, 1974.

Celant, Germano. "Splitting 1974: Gordon Matta-Clark in California," *Domus* (July 1975), p. 48.

D'Agostino, Peter, ed. *Transmission: Theory and Practice for a New Television Aesthetics*. New York: Tanam, 1985.

Donmingo, Willis. "Galleries, Robert Smithson at Dwan," *Arts Magazine* (December 1970 - January 1971), p. 45.

Davis, Douglas and Allison Simmons, eds. *Art Culture: Essays on the Post-Modern*. New York: Harper & Row, 1973.

Greenspun, Roger. "Screen: Palette of Art," *The New York Times* (April 14, 1972).

Gale, Peggy, ed. *Video by Artists*. Toronto, Canada: Art Metropole, 1976.

de Groot, Elbrig, ed. *Edward Ruscha Paintings*. Rotterdam: Museum Boymans-van Beuningen, 1980.

Gurber, Bettina and Maria Vedder. *Kunst und Video: Internationale Entwicklung un Kunstler*. Cologne: Du Mont, 1983.

Hall, Douglas and Sally Jo Fifer. *Illuminating Video, An Essential Guide to Video Art*. New York: Aperture, 1991.

Hanhardt, John G. "Beyond Illusion: American Film and Video Art, 1965-75," *The New Sculpture*. New York: Whitney Museum of American Art, 1990.

——————, ed. *Video Culture: A Critical Investigation*. Rochester, New York: Visual Studies Workshop and Peregrine Smith Books, 1986.

Harrison, Charles. "Art on TV," *Studio International* (January 1971), p. 181.

Heiss, Alanna. *Dennis Oppenheim: Selected Works 1967-90*. New York: The Institute of Contemporary Art, P.S. 1, 1990.

Hendricks, Jon, ed. *Fluxus etc.*, Bloomfield Hills, Michigan: Cranbrook Academy of Art Museum, 1981.

Hirsch, Faye. "Hannah Wilke," *Flash Art* (June 1994), p. 108.

Holt, Nancy, ed. "A Cinematic Atopia," *The Writings of Robert Smithson, Essays with Illustrations*. New York: New York University Press, 1979.

Hopkins, Jerry. *Yoko Ono*. New York: Macmillan, 1986.

Huffman, Kathy Rae, ed. *Video: A Retrospective*, Long Beach, California: Long Beach Museum of Art, 1984.

Independent Curators Incorporated. *Eye for I: Video Self-Portraits*. New York: Independent Curators Incorporated, 1989.

Institute of Contemporary Art. *Ten Years of Video: Greatest Hits of the 70s*. Boston: Institute of Contemporary Art, 1984.

Jacob, Mary Jane. *Gordon Matta-Clark: A Retrospective*. Chicago: Museum of Contemporary Art, 1985.

Kardon, Janet. *David Salle*. Philadelphia: Institute of Contemporary Art, University of Pennsylvania, 1986.

Kirshner, Judith Russi, ed. *Vito Acconci: A Retrospective 1969-1980*. Chicago, Illinois: Museum of Contemporary Art, 1980.

Koch, Stephen. *Stargazer: Andy Warhol's World and His Films*. New York: Praeger, 1973. Second edition, New York: M. Boyares, 1985.

Lippard, Lucy, ed. *Conceptual Art*. New York: Praeger, 1973.

——————, ed. *Six Years: The Dematerialization of the Art Object from 1966 to 1972*. New York: Frederick A. Braiger, 1972.

Lippard, Lucy R. "Distancing: The Films of Nancy Graves," *Art in America* (November - December 1975), pp. 78-82.

Livet, Ann, ed. *The Works of Edward Ruscha*. San Francisco: San Francisco Museum of Modern Art, 1982.

Masheck, Joseph. "Spiral Jetty, a Film by Robert Smithson," *Artforum* (January 1971).

McLuhan, Marshall. *Understanding Media: The Extensions of Man*. New York: McGraw-Hill, 1964.

McLuhan, Marshall and Quentin Fiore. *The Medium Is The Message*. New York: Random House, 1967.

Mekas, Jonas. *Three Friends (On John Lennon, Yoko Ono, and George Maciunas)*. Tokyo: Sha, 1990.

Michelson, Annette and Clara Weyergraf. "The Films of Richard Serra: An Interview," *October* (Fall 1979), pp. 68-104.

Mignot, Dorine and Kathy Rae Huffman, eds. *The Arts for Television*. Los Angeles: Museum of Contemporary Art and Amsterdam, The Netherlands: Stedelijk Museum, 1987.

Newport Harbor Art Museum. *Chris Burden: A Twenty-Year Survey*. Newport Harbor, California: Newport Harbor Art Museum, 1988.

Price, Jonathan. "Video Art: A Medium Discovering Itself," *Artnews* (January 1977), pp. 41-47.

——————. *Video Visions: A Medium Discovers Itself*, New York: New American Library, 1977.

Ross, David. *Artists' Video*. New York, 1975.

Schneider, Ira and Beryl Korot, eds. *Video Art, An Anthology*. New York: Harcourt, Brace, Jovanovich, 1976.

Town, Elke, ed. *Video by Artists* 2. Toronto, Canada: Art Metropole, 1986.

Wallis, Brian, ed. *Rock My Religion: Writings and Art Projects, 1965-1990 Dan Graham*. Cambridge, Massachusetts: The MIT Press, 1993.

Whitney Museum of American Art. *Biennial Exhibition*. New York: Whitney Museum of American Art (Biennial with video since 1975)

——————————————. *Image World: Art and Media Culture*. New York: Whitney Museum of American Art, 1989.

Wilson, William. "Underground Art Films Surface," *Los Angeles Times* (July 2, 1975), p. 7.

Winston, Brian. *Misunderstanding Media*. London, England: Routledge and Kegan Paul, 1986.

Wise, Howard, ed. *TV As a Creative Medium*. New York: Howard Wise Gallery, 1969.

Youngblood, Gene. *Expanded Cinema*. New York: E.P. Dutton & Co., 1970.